IPHONE 12 MINI

THE COMPLETE PHOTOGRAPHY GUIDE

VINCENT BLACK

TIME LOST BOOKS, LLC

BLURB

iPhone 12 mini: The Complete Photography Guide

Apple made the most sophisticated phones that we have ever seen and with it an amazing new camera system. But how do you actually use it to take breathtaking photos?

No matter if you are new to Photography or a seasoned pro, this book will detail all the tricks and tips to get you taking stunning photography in a snap!

The new iPhone 12 mini is a Modern Age Computational Photography monster of a Camera. Apple reworked IOS 14 and the Amazing custom built CPU from the ground up and presented us with an incredible tool, but unless you master it, you will always be held back from getting the great shots that are just beyond your reach. You don't need any prior knowledge. We will start day one and quickly build a set of skills and techniques using simple methods with straightforward easy-to-understand examples and rules to get you out and shooting better on day one.

I break the book down into two chapters, beginner and advanced photography. In the beginning chapters I walk you through compositions, what the difference between the lenses are, your settings,

improving selfies, low light photos and more. For anyone that wants to take their photography even further, there is a ton of additional material in the advanced chapters. The exposure triangle, shutter speed, advance portraits, filters, HDR shooting, landscapes and more!

This is the ultimate guide that will unlock your photos.

TABLE OF CONTENTS
Chapter 1: Welcome!
Chapter 2: Not the Exact Phone

Part One: Beginner's Photography
Chapter 3: 12 Mini vs. 12
Chapter 4: The Three Lenses
Chapter 5: Opening the Camera App
Chapter 6: Understanding the Camera UI
Chapter 7: Settings: Camera and Photos
Chapter 8: Square vs. 4:3 vs. 16:9
Chapter 9: Portrait vs. Landscape
Chapter 10: Live Photo
Chapter 11: Grid
Chapter 12: Rules of Photography
Chapter 13: Panorama
Chapter 14: Burst Mode
Chapter 15: Low Light Mode
Chapter 16: Selfies
Chapter 17: Sharing Photos

Part Two: Advanced Photography
Chapter 18: Focus Lock
Chapter 19: Rule of Thirds
Chapter 20: Exposure Triangle
Chapter 21: Exposure
Chapter 22: Shutter Speed

Chapter 23: Food Photography

Chapter 24: Portraits: Part One

Chapter 25: Portraits: Part Two

Chapter 26: Portraits: Part Three

Chapter 27: Changing the Depth Level

Chapter 28: Using Filters

Chapter 29: Landscape

Chapter 30: HDR vs. no HDR

Chapter 31: Different Angles

Chapter 32: Copyright questions

Chapter 33: Editing

Chapter 34: Wildlife Photography

Chapter 35: City Photography

Chapter 36: Hacking your Creativity

WELCOME!

This is the Quick start guide to talk about the book.

I separate this book into two different categories and two different photographers types.

The first part of the Book, called Beginners Photography, will go over all the features of your new Camera, what the options are and how to use them. We will go over simple and easy-to-use rules to help transform your shots from average to extra-ordinary.

This beginner's photography guide will be short, sweet, and to the point. It will elevate your skills without going into thick hard to understand details. It's not skimming anything, but it's ALOT easier to understand 80% of the material than the last 20%. I write this book in such a way that with the minimal amount of work you can be proud of the photos you take and will show them off to friends and family on Instagram.

But what if that is not enough? And how could you tell?

Which one of these sounds like you?

Do you want to manually adjust aperture?
Do you shoot in Raw and want to edit your photos in Lightroom?
Do you want to manually adjust shutter priority?
Do you like rising the ISO?
Interested in Apple Pro Raw?

Does this sound like you? Then dive into the Advanced Photography section afterwards.

Really, this could be two different books, but I wanted to put them in the same guide. I hope that someone that is interested in Photography might want to dip their toes into the more advanced section, or a Camera Wizard will gain some useful knowledge from the Beginners section as we cover lots of specific details on this exact phone.

NOT THE EXACT PHONE

*T*his is not my exact phone…

As you may have noticed, there are a lot of books on Amazon. Just in the last month there have been 20+ books written and put up about the iPhone 12. Some of them are general user guides and other books about the cameras. Almost all of these books are written about not a specific phone but a series of phones.

For example, on this current 2020 batch of iPhones Apple released, they came out with 4 models. An iPhone 12, iPhone 12 mini, iPhone 12 Pro and iPhone 12 Pro Max.

These phones all have similarities, but they have differences as well.

Many authors choose to lump all 4 of these phones into the same category and just write one book. This system has many advantages but a few disadvantages as well.

The Major Advantage

One book for all four phones guarantees that anyone that buys a current phone can use your book.

. . .

The Major Disadvantage

They are not on the same phone. With this book here, none of the authors even had the iPhone 12 Mini in hand when the book was written so those books tend to be generalized guides. That means a lot of things are left out or glossed over.

You might ask, "What does this mean for you?"

Well, this book is meant for the iPhone 12 mini. That is the only phone that was used for the making of this book. The mini has different hardware, different lens tech, different sensor, it's just a different camera.

What If I don't have that phone!?

Don't worry. Many things in this book will apply to you and help elevate your photography to the next level. You will find it more than worth your time to read this book. Just note that I mean it for one Phone, the 12 Mini.

PART ONE: BEGINNER'S PHOTOGRAPHY

12 MINI VS. 12

his is not a Phone Review. I will not compare parts of the phones that don't really matter to Photography. This is not a pro / con list. I thought about not including this list at all, but figured that it may help some people with understanding their phones better.

The 12 mini is basically the same phone as the standard 12 but in a smaller form factor. There are some variances in the devices but for right now let's consider these two the same phone. This is the first time in years that Apple has given us the full size-power in a smaller body.

The 12 and 12 pros are radically different devices. I could go through lists all day long going over tech sheet after tech sheet, but I just want to focus on your camera. Many people think that the camera system on the normal 12's are radically inferior to the larger pro siblings and it is true those systems are wonderful for photography, but that does not mean you can't take amazing photos with the 12 mini.

Trust me, the 12 mini can handle quick a photographic workload and is plenty sufficient as an amazing camera.

You got a phone for hundreds less than a pro and got a smaller size that fits in a single hand. You made an amazing choice and will still get some great photos with it! You to know why you made a fantastic choice!

CPU!

The 12 mini uses the same A14 Bionic chip as the other phones in this lineup. What this means is that you don't need to upgrade to a pro phone to get the best quality sensor. The CPU is the brain of your phone and Apple uses this technology to improve your photos with a feature called computational photography, which we will cover later on.

This new CPU gives us radically better photos.

1- The iPhone 12 mini has Smart HDR 3 for photos, which is a significant upgrade from the previous HDR. This new High Dynamic Range we will talk about later, for right now lets just say that it's going to product much better colors and darks and lights in the same shot.

2 - Improved low light. Though the pixel count has not changed from the iPhone of previous generations at 12mp, we will still get much better low light shots. This is because the iPhone 12 mini now supports Night Mode for both lenses! This will allow us to capture more light than ever before.

3 - If Video is your thing, the new mini can record HDR video with Dolby Vision to 30 fps! I won't be talking about this much because this is a photography book. Let's just say this is a game changer.

4 - The new mini has a 1200 nits max brightness HDR screen allowing you to view and EDIT your photos DIRECTLY ON YOUR iPHONE! This is next level tech.

5 - The front facing camera (Selfie Camera) now supports both Night mode AND Deep Fusion!

A new Lens!

Another big one. The new Lens can capture more light because of a wider aperture and will allow a lot more light through onto the sensor. This will radically improve low light shots.

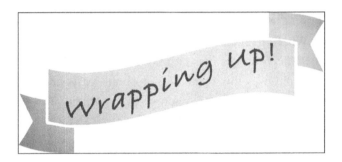

• *New CPU. The fastest ever in a phone and the same one as the top 12 pro!*

 • *New and improved HDR for better photos!*

 • *HDR Editing*

 • *Dolby Vision*

 • *Better Lens with improved low light*

THE THREE LENSES

The 12 Mini comes with two different back Lenses and one front lens. The Wide and Ultra Wide.

The Wide Lens - I.E. 1x

Apple calls this lens the wide lens, which causes some confusion for many people. This is actually the default primary lens for your phone. Every time you take a photo, unless you select another lens, you will by default be using this lens. It is the primary shooting lens for many people and you will use it a lot!

This is an example shot of a bridge using the standard wide lens with the phone turned sideways in landscape orientation. It is shot from a slight angle in a composition that I really liked.

The Wide lens is the go to lens when you don't really know which one you want. The other lens is more specialty lens that you go to get a wider shot angle. This is your general go to lens for everything.

Stick with the standard wide lens for a while but don't refuse to use your other lens. Take a shot with both!

Just because the Wide lens is your go to lens for everything does not mean you should not try out other compositions!

The Ultra Wide I.E. .5

This is the wide of wide. Here is an example of an ultra wide shot.

Compare it to the shot above. It looks like this shot was taken five feet back, right? It's actually from the same position as the other shot taken above. The wide-angle lens is much wider than the standard wide lens and is going to produce a radically different shot! I use this Lens for Landscapes, at the park, when I have things that are wide on each side of the shot, rivers and oceans, etc.

You may notice that things have a bit of a warp on them. The Ultra-wide is a unique lens that gives photos a bit of a warp because of how the lens is designed. Apples solution is to use software to adjust the image back and clean the warp up. But it's still going to be there. You can use this to your advantaged to get shots in a way that would have never been possible without the ultra wide. Notice how in the shot above the board looks wider on the right side where it is closer to the camera and smaller when it gets up to the bridge?

. . .

Love your Ultra Wide, and it will love you back.

Side note.

Some iPhones come with a Telephoto Lens, but the mini does not. If you read anything online that talks about shooting with a 2x, portrait or telephoto lens, just note that your camera does not come equipped with this lens.

So when should I use each lens?

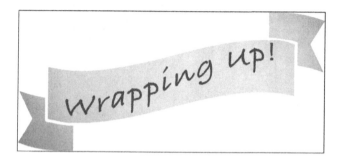

• *Wide is your standard lens, Ultra Wide is zoomed out and Portrait is super tight.*

• *Use the Ultra Wide when you are trying to frame a large shot, or a shot with a lot of things you are trying to fit that are far apart, or for landscapes.*

• *Use the Wide Lens as your general catch all and when you are trying to get a clean shot with as much detail as possible.*

OPENING THE CAMERA APP

4 Different ways to Open the Camera App

This is just a quick note on the ways one can access the camera app.

1. Home Screen
2. Lock Screen
3. Control Center
4. Lower Right Edge Sweep

1. Home screen

You can move the Camera App to any page of your home screen for easy access. It begins on the Main Home page.

2. Lock Screen

On the lock screen, it is all the way in the lower right corner. You must do a long press for the camera app to open.

3. Control Center

To access the Control Center, sweep down in the top right corner with your battery icon. It opens up the control center. My camera app is in the lower right corner.

Hard touching the icon will bring up a quick menu for your use.

4. Lower Right Edge Sweep

With this you just pull the screen from the lower right edge and sweep left.

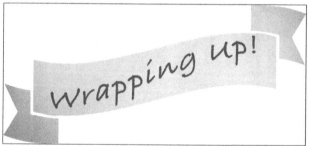

• *You can get to your camera app anyway you want. Try all the different methods to find the one you like the best!*

UNDERSTANDING THE CAMERA UI

*U*nderstanding the Camera UI
The iPhone Camera UI has lots of distinct features and we will go over each one on for the iPhone 12 mini.

Camera Mode
- Photo
- Time-Lapse
- Slo-Mo
- Video
- Portrait
- Pano
- QuickTake

- **Camera Settings**
 - Zoom
 - Flash
 - Night Mode

- Live Mode
- Aspect Mode
- Exposure
- Timer
- Focus
- Burst Mode
- Grid

Camera Mode
Photo:

This is the standard mode, and the first one you see when you open the Camera App. You use it for still photos and you can combine it with Live Mode to watch the photos come to life.

They are two different lenses on the iPhone 12 mini.

Ultra Wide Lens (0.5x)

And Wide Lens (1x)

Notice the 1x and 0.5x? Just tap it to switch back and forth between your two lenses. Easy as pie.

Time-Lapse:

This is a great little video mode. You can capture footage to create quick, easy to share videos.

Slo-Mo:

Used for mainly athletic footage, nature, or to create artistic, unique video clips.

Video:

This is the basic recording of video that you would for normal use.

To quickly get to this option you can on the Photo tab you can press and drag the button to the right.

Portrait:

This mode is keeps your subject sharp while blurring the background. It gives you a depth-of-field to bring a subject into a nice sharp image.

This gives options for filters from natural light to stage light.

Pano:

This is also called Panoramas. This is for creating a long, wide photo. Think landscape like the beach or a mountain range.

Camera Settings

Quick controls to open the camera setting is this button on the top of the screen.

Flash:

Has two options, manual and auto. The Auto Flash will detect how bright it is and decide if it needs to add light to the environment. Manual lets you choose if you want that light on or off.

Night Mode:

Night mode uses camera software to help capture detail and color in your night photos.

Live Mode:

Live Mode brings your still photos to life. It creates a small 3 second video of the still image.

Aspect Mode:

This is where you can choose different aspects like 4:3, square, or 16:9.

Exposure:

Exposure is the brightness of the photo. You need to make sure the you have a balance of just enough light to not being overly dark. You have the option to turn this on or off in the setting tab.

Timer:

Is great for taking a photo with you in the scene. You can set it up, place the timer and get in the photo.

Focus:

The focus is a hidden feature of the iPhone. So setting it, make sure you frame your subject, then tap the screen and a yellow box will show up and your subject will now be the focal point.

Burst Mode:

Burst mode is an effect that you do on your phone. To do burst mode, all you have to do is slide your finger to the left and it will continue to take photos until you release your finger.

You can also add it to the volume up button, you can find that in settings tab.

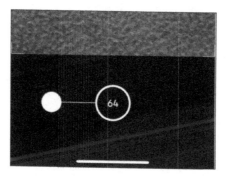

Grid:

Using the grid can help with compositions so you can get some eye-catching photos. Using the grid line helps with horizon levels, ensure lines are straight or level, your rule of thirds compositions, and even to create symmetrical photos.

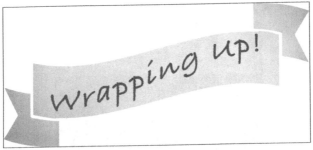

• *Keep this chapter bookmarked so you can bounce back to it when trying to learn your UI. eventually you will rip around it at lightning speed!*

SETTINGS: CAMERA AND PHOTOS

*T*ime to go through the various Camera and Phone settings on the 12 mini.

I will keep this short, but figured I would expand on some details that the tooltip leaves out.

Photos:

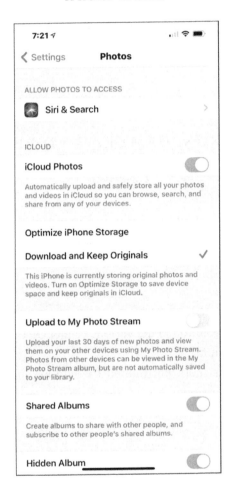

Allow photos to access is just giving permission for photos to show in Siri and Search. I turn all of these on.

iCloud Photos

Allows me to access my photos from devices other than my phone using the internet. I turn this on as I will sometimes edit photos on my iPad from the couch. Turn it off if you don't use iCloud or don't want to use online storage.

Note - I also keep backups of all my photos on external drives. Just because…

. . .

Optimize iPhone Storage vs Download and Keep Originals.

This one is pretty simple as well. It will upload photos you take to iCloud to save space on your phone. I turn this off because I prefer to keep the original files on my phone. Your call here.

Upload to my Photo Stream

This allows you to see the last 30 days of your photos on other devices. Some people use this instead of iCloud but I do not. I use iCloud because I will sometimes work on photos that are longer than 30 days.

Shared Albums

Pretty simple. I share whole Albums with friends and family. I turn this one on.

Hidden Album

I keep a Hidden Album on my phone whenever I am shooting something sensitive for a client. It's not much but I feel like it gives an extra step of security.

Cellular Data

This feature allows your phone to use your Cellular Data line to upload to iCloud. I turn this feature on, but if you are on a limited data plan or concerned about your data, turn it off and do it over Wi-Fi.

Auto-Play Videos and Live Photos

This just allows you to quickly and easily play Live Photos. We will go through Live Photos later. I turn this on.

View Full HDR

If you take HDR (High Dynamic Range) photos on your camera, this function will allow the screen to display them correctly. You could turn this off if you wanted to see how legacy devices would display your photos, but I leave it turned on full time.

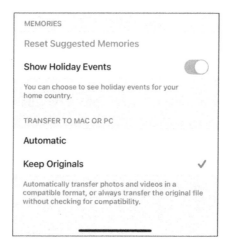

Memories

Memories are an amazing function of your iPhone. It will automatically make a collection of photos from events / birthdays / special occasions and compile them into a short movie. If you have not yet used memories, you will love it. Turn it on.

This tab allows you to reset suggested memories, but I can't see any reason why I would ever do that.

Transfer to Mac or PC
Automatic transfers photos and videos to a more compatible format for the computer to read. Keep originals is going to transfer the file with the settings I told it to use and not convert or change it in any way. This is the setting I use, Keep Originals.

Camera:

Formats are up first:

Formats

These feature is talking about what kind of file format you want to save things at. You have two options here. High Efficiency and Most Compatible. High efficiency of HEIF/HEVC is a modern format that does a better job of preserving details at a smaller size than JPEG. It is slightly less compatible with some legacy hardware and editing software. I use High Efficiency. The quality is the same either way.

Record Video

This tab allows you to select the video quality/size of your video files. This book is about Photography, and this tab, and **Record Slomo, Record Stereo Sound**, doesn't affect us. But to quickly state the higher the numbers are, the better quality you get but sacrifice in size. The higher quality video formats will take up more space, just like higher quality photos.

Preserve Settings:

We got a few options in this submenu:

Camera Mode

This button will keep the phone locked in whatever mode you left it on. By default, it goes back to the camera app. So if you moved it to video it would bounce back to camera. I turn this off.

Creative Controls

This allows your settings to be held when bouncing back and forth between different lenses. I could not advise you to turn this on fast enough.

Exposure Adjustment

The default is for the Exposure to reset whenever anything changes. If you turn this off, it will add an Icon to your user interface

to allow you to select your exposure much faster and preserve your settings between shifts. I absolutely recommend you turn this on.

Live Photo

This option will save your Live Photo settings instead of defaulting it to on. I turn this option on.

Next up is Composition:
Grid

This will turn your 3x3 composition grid on. Sometimes I shoot with it on and sometimes off. For right now, turn it on. We will talk about the grid later on.

Mirror Front Camera

This will flip the origination of your front selfie camera from one side to the other. I turn this off by default but will turn it on now and then when my composition demands it.

View Outside the Frame

This allows you to see what will sit outside of your photo. I leave this turned on because it helps me compose a shot to see how it might look if I did XY or Z. But it's a stylistic thing.

The Last Section is Photo Capture:

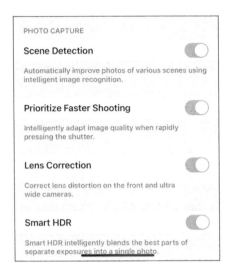

Scene Detection

This is magic AI Wizardry cooked up in Apple Secret Laboratories. It uses artificial intelligence to improve your photos by recognizing what kind of photo you are trying to take and then adjusting the camera settings to give you the photo you wanted to take, but needed its help to do. I turn this on by default.

Prioritize Faster Shooting

This allows you to shoot burst photos and never miss a shot. I turn this on and there is really no reason to turn it off. Press the volume up button quickly to take a bunch of photos, or hold it in for burst mode.

When this mode is on your phone will take less time improving your shot. So with burst mode on you lose quality, right? Not really... Think about it this way. When you care about quality, take a photo. Do you

need the speed, shoot in burst. But ONLY shoot in Burst mode when you need it, if you don't need it shoot in normal mode. That way you get the best of both worlds. Speed when you need it and quality everywhere else!

Lens Correction

Because of how the Ultra Wide Camera and Front Selfie camera are created, they have a bit of a warp to them. You will want to turn this button on to fix that with software. I turn this on. I will only turn it off when I have a shot where I don't want the correction. Not common.

Smart HDR

See the chapter on HDR vs non-HDR later on in the book. I always turn this on.

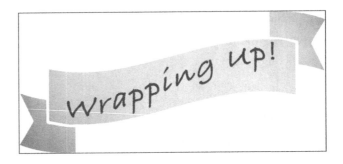

• *And that's it! You now know a bit about your Camera settings and how I set all of mine up!*

SQUARE VS. 4:3 VS. 16:9

*T*his one is going to be a bit of a doozy.

This part of the book is going to be very opinionated. Aspect ratios and res in our shots is something that photographers feel very strongly about. Like most creatives things, photography is part analytical but also part expressive as well. Some people will just prefer on to the other. If you think your shots look better in one or the other, please shoot your shots how you like!

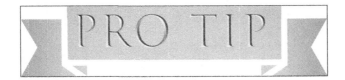

You don't have to be stuck in one format. You have quick and easy controls to allow you to change from one style to another, mix it up!

Most of this is going to center on 4:3 vs 16:9 and its pros and cons, but we will talk about Square first.

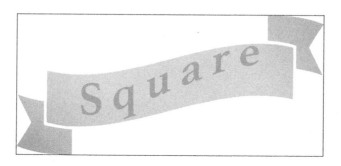

Square photos have existed for a long time. Think of a square photo as a print made at 4x4. It's square on all sides. If you want to print a photo at 4x4, or downsize to 2x2, or up size to 6x6, you have two choices. Crop a photo shot in a different size square or shoot in a square. Most of us do not shoot in square format, and if we want to print in square, we crop to it. But it is an option.

Square photos were the defecto on Instagram for a few years, but they have recently changed to full images. Did that invalidate square photos and make them useless? Of course not! It's a compositional choice, just not one that most people shoot with.

Experiment with it, see if you like it.

4:3 is the go to format for everything. It's the one I and most other people shoot in. I will go through the pros of 16:9 in a few pages, but 4:3 pretty much knocks its socks off.

Before I go through why, let's talk sensors. We touched on the CPU/sensor combo before in chapter (3: 12 Mini vs 12) but need to talk about it again here.

The Sensor in your iPhone is not square, but a rectangle. When you take a photo, light comes through the lens and gets captured by the sensor. Without getting too complicated into how the sensor takes a photo lets just say that light goes throughs the aperture (the hole in the lens) and is captured by the sensor. The sensor in the 12 mini is closest to 4:3. Other Cameras may have a different sensor size, but 4:3 is the default that everyone uses.

And the benefits are enormous.

 • *4:3 captures a 1:1 image exactly as you aimed and shot it. It won't crop the image and cut parts of it off.*
 • *It scales in print. 8x10 / 16x20 are best from a 4:3 capture.*
 • *No Lost pixels / Highest resolution shot.*
 • *No size reduction from shooting at 16:9*
 • *If you want a 16:9 shot, you can always crop down afterwards, but it's hard to crop a 16:9 to another resolution.*

Bottom Line. We shoot video at 16:9 but photos at 4:3. Your Sensor is 4:3 why would you shoot at anything else?

16:9 is used for film, movies, computer monitors and our televi-

sions, so why not shoot Photographs in it as well? I mean, 4:3 beats it out but it has to have some advantages?

And it does.

Benefits of 16:9

When looking at photos on your computer, your monitor is most likely 16:9. The Photos will be the same resolution as your computer screen.

Sharing family photos and viewing them on the TV. Most TV's are now 16:9 as well.

But that's about it. Shoot in 4:3 and crop to 16:9, or shoot in 16:9 for video.

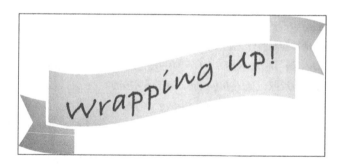

- *4:3 is king.*
- *If you want 16x9 crop down*

PORTRAIT VS. LANDSCAPE

One of the first questions people get to when deciding how they want to frame their shots is if they want to frame it in Portrait or Landscape mode.

Portrait mode, also called Vertical mode, is the standard orientation that you hold your phone in. Most of us only turn our phone sideways when watching a movie or playing a game, but we keep our phone standing straight up in Portrait mode.

Landscape mode, also called Horizontal mode, is the standard for film, movies and games. Most of the things we consume as a digital medium come in Landscape mode, but it is also an extremely useful format for photography as well.

Most of us tend to think that Landscape mode is for shooting Landscape shots, when we are shooting outside and taking a photo of land, mountains, rivers, etc. But Landscape mode can do a lot more than just mountains.

But if there is not always a default of which to fall to, how do I decide which one to shoot in?

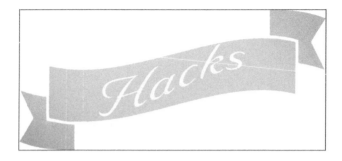

The way I like to think about it is which one fits the elements I want in the photo. What is it you want to get in the photo? Don't just shoot landscapes in landscape orientation, instead ask yourself what it is you want to see in the final shot. Every scene is different and is a unique opportunity to get your photo, your expression, your style.

Let's look at these two photo examples:

The shot on top is in portrait mode, and the one on the bottom is in Landscape. Which one of these shots is better than the other one?

Well, that depends. The top shot shows the top of the fence, a tighter more detailed view of the sidewalk, a closer view of the tree, the color and separation of the leaves, etc. The bottom shot shows a wide angle curve to the sidewalk, all the bottom branches in the frame and their intertwining, the area on the ground next to the tree, cuts out more of the background, etc. Which one is better? It's an artistic choice. If I wanted more of the top list, then Portrait mode was the correct choice. More of the bottom? Landscape.

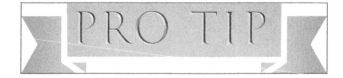

Does anything distract from the intended subject when you switch from one mode to other? That is a substantial reason to shoot in a different orientation.

So how do I decide which orientation to use? Ask yourself, what is your subject? What highlights them? What detracts from them? Once you have these questions answered, you know how to frame your shot AND what orientation to use!

Let's look at another shot here:

Let's talk about these two shots for a bit. In both shots, the subject is a person. At no point should the subject be confused with the window behind him, or the tree, or the building, or anything else. The Subject was always a person. So as I frame these two shots, I want to decide which one does what I want. I do the pose slightly different in them, because I think each pose highlights certain things that I like better here, so this is not a direct apple to apples comparison, but it is close enough to bring my point home.

The selection in the back window is distracting in both shots. If I was to edit this photo, I would work to blur or smooth that out. The

exposure is always adjusted here slightly because I wanted to get the darkness of the tree a bit in the landscape photo.

So which one is the better photo?

I like the Landscape photo at the bottom. I feel that the tree and his arm on the tree highlights him, the slight angle does as well. I feel this shot is more personal, more detailed, even though it is busy. It shows a city street shot with my subject interacting with his environment. Could the top shot be better? Sure, if that is what you wanted to aim for.

It's your photo! What are you trying to show?

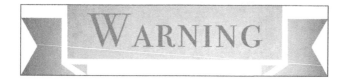

When taking photos and posting them to the web (Reddit / Insta-gram, etc.) remember that people use their phone in Portrait Orienta-tion and thus most of the photos they view are also in Portrait mode. Shoot however you like, but it's always good to be aware of how your photos will be seen when you upload them.

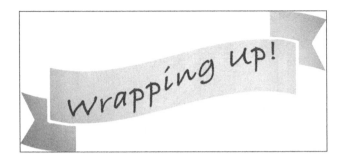

• *Be aware of all the elements in a scene. Use them to your best advantage and allow that to help you make your orientation decisions.*

LIVE PHOTO

*J*n this chapter, we are going to go through Live Photo and answer some questions!

• Should you use Live Photo?
 • Pros and cons?
 • How to play a Live Photo video?

Live Photos is a built in Apple tech, that bundles a small video (with audio clip) into a still image. It's sort of like an animated GIF with audio that your phone creates automatically. Live Photo has some amazing benefits and I shoot with it turned on most of the time.

Let's think of an example scenario:
 You sit down for family photos over the holidays, bundle everyone into the same shot. Let's say you have 13 people in the shot. You snap the photo, and two people blinked, and one more was suppressing a yawn.

Most of us have been there.

Enter Live Photo.

Because you have captured a video with your still photo, you can then go through this 3 second video afterwards frame by frame and select the one where no one is blinking.

Let that sit in for a second.

You have a video attached to your photo that allows you to reframe, edit your shot. Think of all the shots that this enables you to get. Movement and action shots.

Live Photo requires you to wait for a second after you take the photo. If you move as soon as you hear the shutter button then the Live Photo option is still trying to process and it's going to mess up your image. Give it a second before and after while keeping the camera still!

Of course everything has its downsides. Live Photo is not perfect at all, and there are some drawbacks to it.

1- You need to keep the camera still a bit before and after the shot, even after you hear the shutter close.

2- It takes up a lot more space than just a photo would. Think about it like this, every photo you take now comes with a 3 second video. This video eats into your storage space.

3- It can produce a lower quality photo in some situations. For example, in very low light scenarios the A.I. will increase the ISO a bit to capture the video and this can/will carry over to your photo. Live

Photo will never affect your photo quality in normal lighting conditions, but turn it on for very low light issues or you might get grain in your photos.

4- Using Live Photo the Pro Max will use a slightly faster shutter speed. This will cause slightly less light to come through. In well-lit areas, this won't affect your shot much at all.

Though these things may sound scary as per the loss of the quality on photos, I would challenge you to find any loss in quality in your shots. There is a theoretical possibility of less light, true, but it would be hard to find an example of loss of quality. Five years ago? Sure. The 12 Mini? Its rather amazing.

Portrait mode will not work at the same time as Live Photo, so you must choose one or the one.

If you don't like Live Photo, you can always turn it off in settings.

• *To Watch a Live Photo video, just select the photo from the photos app and press and hold on the screen. You will get to watch a short movie for when the photo was taken!*

• *Remember that Live Photo comes with audio, so don't accidentally send anyone anything that could be embarrassing.*

• *You can always turn Live Photo off the photo after it's taken in the photo app.*

• *You can also cut stills directly from it and delete the Live Photo afterwards, why not use it?*

GRID

*T*he grid is a useful setting to turn on. It will help you line out your composition. We will learn about the Rule of Thirds later, and the grid will help you take advantage of that.

To turn on the Grid mode, go to your camera settings in "Settings" and go down to Composition.

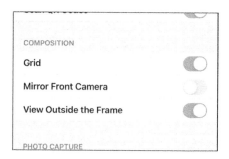

Click on the Grid option to turn it on.

Now when you go to take a shot, it will show you your photo in Grid form.

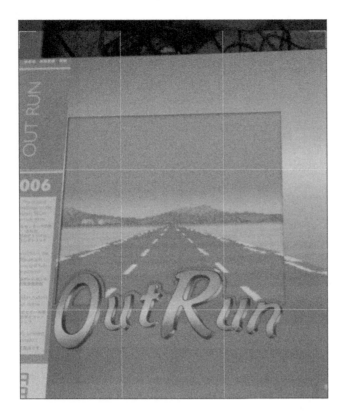

This grid allows you to see your photo in 9 sections, or 3x3 squares. This can be very helpful when trying to figure out how to get certain elements in your photo into the same areas, or setting focus points on certain lines.

Don't worry, the grid lines won't show up in your photo they are only there to help you with composition.

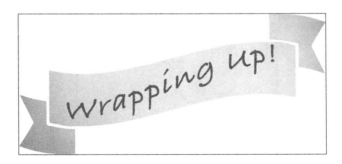

• *Use The Grid lines to help you layout composition!*

RULES OF PHOTOGRAPHY

There are many "Rules" of Photography. For each rule that you find that promises that if you follow its principles you will prosper in the great river of tranquility. But then another sub rule will come in and contradict that rule and show you the never ending torment that follows from not heading it.

Having said that, I still have a rule for you.

Take a lot of photos.

When I sit down and compose a shot, that's it! I shoot. I line up the angle, dial in my settings, and go to work. Then I check the shot and make sure it looks how I wanted it to look, and in my mind, I'm done. Usually I think I got it right. Sometimes I just don't care another to look for a different angle. Sometimes I just want to get a shot or two in and then move on. Sometimes I'm in a hurry and I want to rush between shoots, or I have a limited amount of time with a subject. When at a wedding I have milliseconds, not seconds to get my shot. That owl on that branch is going to fly at any second. So I train myself into a system where I shoot fast and quick. Compose then go.

I have to remind myself to sit still and breathe.

I saw these Mushrooms on the side of this stump the other day. I thought it would make a great little shot. A little color from the leaves, a little rule of third. But the shot did not look great as I took it. My quick scan said that my exposure was off. I wanted more pop from those leaves and a bit more color separation from those mushrooms.

That reshoot was much better. It got the colors I wanted. I was happy with this shot in preview. I could have let it slid there.

I'm glad I didn't.

I took this shot after I was happy with the shot above. I toned down

the color a bit more than I thought I wanted in the shot. This is not the image I had in my mind when I shot these Mushrooms, but I got rid of a lot of noise from the shot above and cleaned out some details I would have missed otherwise.

Why did I shoot this extra shot? Honestly, I don't know. I felt like I had the correct shot, but still took about ten more, anyway. Some from the other side, some on different exposure. I found out which one I liked later on in edit, not on my phone screen. I would have never seen it if I did not take extra shots.

Just take a lot of photos.

I'm not telling you not to compose your shots. Don't walk around with burst mode turned on permanently. To improve your photography, you need to improve your composition. What I am saying is not to line up that one perfect shot, take it, and walk away. Compose your shot, then take it, then take some extras, then change and take more. Then recompose and do it again. And again. As often as you want. You will get a better shot and learn much more in the process!

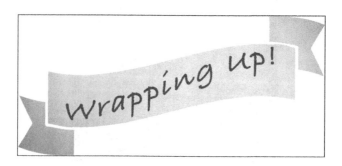

• *Take Multiple shots*
• *Rethink your original composition after the first set of shots, then re-shoot*

PANORAMA

*E*ver see ultra wide photos like the ones above that seem to show an entire landscape or city in one shot? These kinds of photos are called Panoramas.

A Panorama is a wide-angle shot of any scene. It's usually much

wider than what we normally take with the ultra wide lens. The iPhone 12 Mini uses software to stitch multiple photos together into one longer shot to take a Panorama photo.

Moving subjects make poor Panorama photos.
Let's look at a Pano photo:

This is an outstanding example of a pano photo taken from behind second base of a baseball field. Believe it or not, I am only about 8 feet off the dirt when I shot this photo, so there is no way I could have gotten this entire shot in without pano mode.

After opening the photo app, the ui will default to photo mode. If you slide it twice to the right, it will select Pano mode. You can use pano mode on either of your two lenses, which I will get to in just a second.

To take a photo in pano mode, you will hit the button and then slowly drag the phone crossed the area that you want to photo taken. There is a max distance that it can record, so 360 degrees is out of the question, but you can take in a very wide shot with it.

Let's look at some photos from this shoot:

This is our base shot. I shoot it with the wide lens and I wanted to get in both sides of the field, including a touch of grass.

Here I'm going to switch the lens to the Ultrawide. This is what we get.

As you can see, this mode gives us a much wider view but also pushes us farther away.

Panorama photos require different composition then normal photos. Practice them when you go out and shoot so that when the time comes to take a good one, you understand the composition rules for Pano photos!

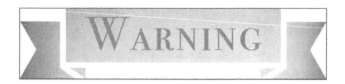

When trying to take a pano photo, you have two worries to look out for. Speed and stitching.

Speed

If you move to quickly, the arrow will make an adjustment telling you to slow down. Your camera needs time to make these multiple photo stitches and you can't go to quickly.

Stitching

In this example, you notice how the field looks like it was chopped in half? When taking a pano photo you have to not only go slow but also keep the phone at the same level as it was when you started the photo. If not, you will get clipping as seen in this photo with the field and the black section cut out of the photo at the bottom.

The more motion, the worse the cut.

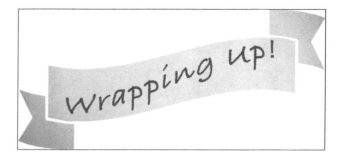

• *Stay as still as possible and move slowly when taking Pano shots.*
• *Don't wait till you have a great pano shot to take your first one.*

BURST MODE

*B*urst Mode is rather straightforward. Any time there is a shot with a ton of motion, rather actions, sports, fast moving animal, anything that really prevents you from framing the shot you can use burst mode to capture a subject that you never would have gotten normally.

Burst mode is activated by holding in the volume up button on your phone. It will take a second to start and then will start taking rapid photos in quick succession. Using it, you can get just the right expression on the baby's face, or that first bite of wedding cake.

To view your burst photos, go to the photo app and select the photo. It keeps them all bundled at first. Hit the select button on the bottom. From there you can scroll left or right to look at all the photos taken in that burst! After selecting the photos you want click done and it will give you an option to keep everything or keep only the favorites you select!

This amazing feature makes it to where you never miss a shot.

So when should you use Burst mode, and why not use it every time?

Anytime you have an action shot, try to use burst mode. Swimming, sports, jumping, rollerskating, etc. Afterwards you will get to select your best shot and will have one you like in here!

Got it. So Burst mode is for action shots. What else can I do with it?

My favorite use of Burst mode is actually taking photos of people. But not in sports, movement or actions shots, but for candid photos. The best shots of people are ones where they are not posing but are living. If the subject is ignoring the camera, or better yet, not really even aware, my shots gain a lifelike quality.

The problem with this, of course, is that my subject is probably moving around a lot and asking them to slow down and stop would ruin the whole idea of me trying to get "real shots." I get the best expressions from my subjects when shooting in Burst mode and get that personal interaction with the world that is missing out of staged shots.

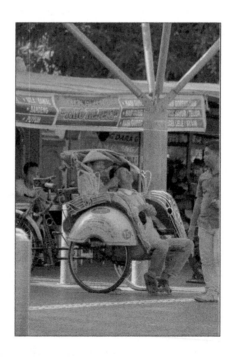

These expressions were possible because of Burst mode.

. . .

A Jogger ran by me the other day, and I had my camera out. I was shooting some deer near my local park and could spin around and get a shot. I had only a second and could not really frame anything. After they got by me I got to thinking how could it would be if I had a shot where both feet were still in the air while they were running.

Let's look at the shot here:

Exactly what I wanted. I would have never got these shots without Burst mode.

So, I've got you convinced. Full-time burst mode all the time.

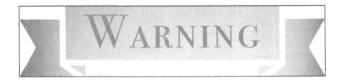

Not so fast. Burst mode has three major problems.

1 - It takes up more space than normal. You are taking a lot more photos, so this takes more space.

2 - You have to go through and select the photos afterwards, which would be a pain if you were looking through a few thousand photos from a shoot.

3 - And this is the big one. No Deep Fusion.

Deep Fusion is the AI Wizardry software that Apple uses to make your photos the best they can be. Without it you are probably taking a photograph at a significant quality drop. No HDR, no Deep Fusion, no extra processing.

So when should I use Burst?

When you need it or when you think you might want it for a more organic shooting.

When should I avoid using Burst?

When quality is more important than speed.

Go capture running water going from someone's hand back into the pool. Use Burst mode of this shot and go back and get the perfect photo of a splash or water droplets at the perfect time.

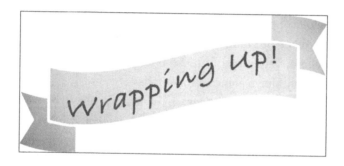

• A photo you take is always going to be better than one you miss. Sometimes quality sacrifice is worth a lot more than a blurry photo.

LOW LIGHT MODE

*T*his chapter is going to be going over Night mode, and how to take photos in Low Light.

A photo taken at night, or any photo in with a low light, is called a low light photo. Traditionally these photos would have a lot of problems, and we will have some of them today.

Traditionally shooting in low light makes you decide between a high ISO setting or a slower shutter speed. Higher ISO will add noise into the shot, and slower shutter will give you a blurry image. I prefer a clear shot with more noise than a blurry shot.

To combat this, Apple introduced Night Mode a few years back and the new iPhone 12 really delivers on that initial concept.

First, let's talk about how to activate Night mode.

Open your camera app at night.

That's it!

Your phone will automatically detect that you are trying to take a night mode photo and will put you into the correct shooting mode.

The sign for night mode is the circle in yellow.

When you see this icon, you know you are shooting in Night mode. The number afterwards tells you how long the shot will take to take.

This is what the bottom of the screen looks like.

As you can see, your mini can Handle Night Mode on either of your lenses. It also shows you the night mode selection tool on the bottom of your screen. You can select it to turn night mode off.

You can adjust the slider to take a shorter or longer photo, and the different lenses will allow you to slide the bar to different lengths. The longer shot, the more light comes in, but the longer it takes to get the photo, the more sensitive it is to any kind of movement.

And that's one kink with Night Mode. It takes a long time to get the shot in. Remember talking about Live Photo and giving it time. Well, this takes even longer. Is it worth it? Of course! But you have to learn how to shoot with a steady hand.

You can get the delay all the way up to 10 seconds!

When shooting the sky, stars, moon, or anything with distance, you really have to keep steady. A good Tripod is an imperative tool to purchase for your photography. It will help you not only in low light photos but in many types of shots where you need the camera to stay still.

One thing about night mode shots and setting the delay up is that by allowing more light through the lens, you are also going to expose the shot to that light as well. Let's look at the photo example here:

I promise you the sky was black when I took this photo. Night Mode will sometimes mess with the colors, and what you see with your eyes is not 100% what you will get out of your lens. The longer delay the more light, the less delay the less light.

More light

Less light

Light works a bit differently at night time. Be careful for overhead lights and lamps as they can create a real glare effect on your photos.

Sometimes you may want a blurry shot! For example, have someone stand with a glow stick and slowly move it in front of you while taking a night mode shot for an amazing night mode photo!

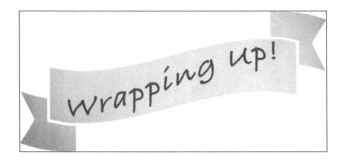

• *Although low light shooting and Night Mode are not perfect, it is by far the best solution we have ever had and your iPhone 12 is the best camera Apple has ever made to handle these difficult shots. Don't be afraid of the dark, embrace it!*

SELFIES

*M*ost likely you have been taking Selfies for years now. Here I will go over the tips and tricks of how you can improve your selfies and knock your friend's socks off!

A Selfie is just a photo you are taking off yourself using your iPhones front facing camera. But since we are taking photos of ourselves, why make the same boring photos again and again?

1 - In Photography, even Self Portrait, Light is everything.

Lighting is probably the most important tool in the toolbox of any photographer, and there is no difference here. Make no mistake, pleasant light will make and break your selfies. You need good lighting. If you are outside in amazing daylight, you will get amazing photos. Inside, find a window. Hold a piece of white paper under your chin to bounce the light back and illuminate your face. Whatever you can. But pay attention to your lighting.

Lighting will take your shot from this:

To this

2 - Look up slightly towards the camera.

An easy composition hack is to look up at the camera. We want to remove the chin and neck from the equation, that is what we get when we shoot looking down at the camera. We want to focus on the face and the eyes.

3 - How to smile

Smiling is easy. Think of something that makes you happy and let your face do that. When most of us smile, it looks fake and artificial, instead think of whatever you enjoy and your smile will look more natural.

4 - Try to avoid using the Flash

Shadows make horrible self portraits. One way to get rid of them is to use the Flash. Try to stay away from doing this. It will just blow out your exposure. Instead, figure out how to get good lighting inside of your composition then just looking for a shortcut.

5 - The Rule of Many Shots.

Remember this one? If not, there is an entire chapter that talks about how and why you shoot a lot of shots. Do it here. And I mean A LOT!

6 - Play the Angles

Don't shoot straight on. Hold your Phone slightly to the side and take the shot at an Angle. It will look much more interesting than a standard front facing shot.

Don't forget to take Selfies using Night mode!

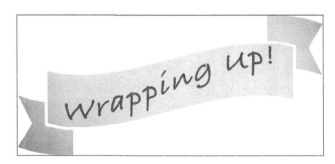

• *Remember the other tricks you learned in this book. Use them all here.*

SHARING PHOTOS

So you've gone through everyone of these chapters and took a bunch of amazing photos. What to do next?

It's time to share them!

There are 3 major ways to share photos

1- Share a single photo.

Open up the photo and tap the [square with up arrow Icon], then choose the method that you want to share. Most photos are sent out via text from this menu, but there are some other options as well.

You can add the photo to an album or a shared album.

You can also copy an iCloud link and send it out to people that way so they can download a full res file later.

You have direct options to print here as well as many other choices.

2 - Share multiple photos.

You can share a full album by selecting the photos you want to share and then clicking the [square with up arrow Icon], Icon. Then select a share option and decide how you want these photos shared.

. . .

3 - iCloud sharing

If you use iCloud, you can send people a link to view or download entire folders at one time. This is a perfect solution for sharing every photo from an event with friends and family. It's lightning fast and allows them to download the photos for up to 30 days. The link can then be shared via iMessage or email.

iCloud download photos are full res quality! Don't be afraid of quality drop when sharing this way.

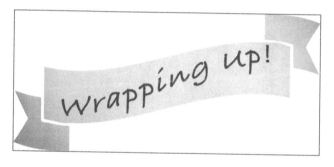

Congratulations on making it all the way through the basic section of the book. I tip my hat to you and your newfound photography knowledge! Now you just have to decide if you are going to get out and practice your skills or move onto the advanced chapters!

PART TWO: ADVANCED PHOTOGRAPHY

FOCUS LOCK

The iPhone and a standard DSLR camera are not identical in how they focus. The Pro Max uses software to set and lock Focus, which differs from the standard Aperture turn that a traditional camera would do. Because of this, some folks feel that the iPhone lacks a good way to adjust Focus. To deal with this problem, apple gave us a unique feature called Focus Lock.

Take this pen here:

To get that yellow box to come up, I held that spot on the screen for a few seconds. That tells my iPhone what I want to focus on. The AI software on the phone does a superb job of picking up what subjects that I want to focus on, but now and then it will give me a false signal. Like my reflection in that glass, or the record, when I wanted the Pen. So sometimes you have to tell it where you want your focus on.

The problem with this is if you move at all it is going to reattempt at another focus lock. Maybe on the item you focus last and maybe something else. So let's lock it down.

After holding that focus box for a few seconds, let go and look for the message AE/AF Lock.

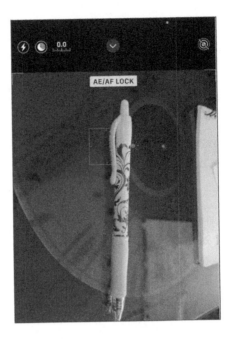

After locking my Focus I can then move around my shot slightly while retaining focus on the pen to get this shot.

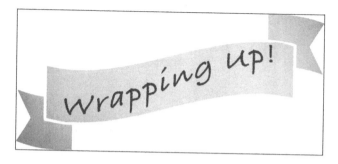

• *Use Focus Lock whenever you are having problems with the software selecting your correct focus and want to lock it into one spot.*

THE RULE OF THIRDS

The Rule of thirds is one of the better known rules of photography. It's not always accurate, but can be an amazing tool in your toolbox.

When we do composition for a photo, we approach it first with our eyes. I look at the shot and see if it would make a wonderful photo. Sometimes I want to capture a moment, but even then I try to "frame" it correctly. I think about what my subject is and then look around to see what will compliment them.

So I center my subject and figure out how wide or close I want my shot and then what works with them. I Snap my photo and a few others just to make sure and off I go.

Afterwards, I am looking at the photo. It looks… fine. I guess. A bit boring. Technically, it looks ok. Person in the center - tree to their left and large rock to their right with the mountain in the background. It looks like the same photos I took last week, and the week before that. It's… Boring…

The Rule of Thirds attempts to introduce composition rules to create a much more interesting shot. The basics are moving the subject off center of the shot.

Ok... I know it sounds odd. You may have just reread that section above and wondered if I was off my rocker.

Allow me to explain.

The principle of the rule of thirds is to break down a image into horizontal and vertical thirds, so that you have 9 parts.
Let's look at a example:

1	2	3
4	5	6
7	8	9

This shows each of either sections of our photo. There are 9 primary boxes that we are working with in our composition.
Let's look at another example:

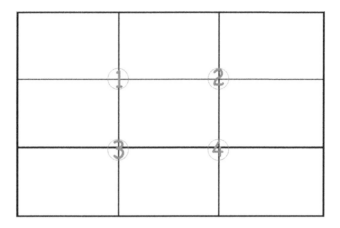

So from here I am going to place a point of interest in the intersections of one of those lines. Doing so should in theory make my photo more balanced by not having the subject large and centered. It will look more natural.

So why not place my subject dead in the center? Is that not what I am shooting? Well, the human eyes actually move closer to one of those intersection lines than the center of the shot. If the eye already looks off center first, I bring my subject front and center by not placing them in front and center!

Think of it this way. The eyes are the windows of the human soul, right? So If I place my subject in the center of that box then their eyes are not natural.

This shot is the way we see people. I want to emulate the way my eyes work. That way I can create additional points of interest as well. The book, the lamp. Even the pencil. We don't look at people with our eyes in a center frame, everything is slightly off to the side.

Let's look at a few more photos:

We have very different photos here. Each one is shot in different lightning with different subjects. But one rule remains the same in all of them. The photo is a much more balanced shot incorporating elements that would have no been felt so strongly with the shot was straight on with a centered subject.

If you intend to break a rule, always learn it first. That way you are breaking it for a reason, which will make it even more effective when you do so!

To be fair, rules are meant to be broken. If you don't use the Rule of

Thirds, are your photos going to be unbalanced? Boring? Not necessarily. But it gives you a new option and another perspective.

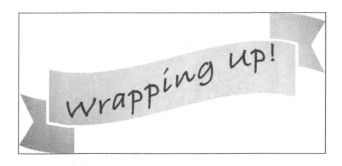

• *Use the Rule of Thirds.*

• *Sometimes keeping the center of center is best, as it will often highlight your subject more than if you kept it dead in the center.*

• *A Balanced Photo is a happy photo!*

EXPOSURE TRIANGLE

Understanding **The Exposure Triangle**

As its name suggests, the Exposure Triangle is made up of three parts: Shutter Speed, Aperture and ISO. This chapter will go over each one so you understand more of what the terms mean on the iPhone 12 mini.

How the Exposure Triangle works is if you change one side, then at least one of the other two will change as well. Think of different triangles. You can have an equilateral or a right triangle, and how you set up each one differs on what you want from the photo.

1st side: Shutter Speed

Shutter Speed is the easiest to understand of the three. It measures the length of time light is allowed to hit the sensor. It starts at 1 second and works down, going by half each time. When you have a faster shutter than it gives the sensor less time to collect light, and if you have a slower shutter than it allows more light to come in and it results in a higher exposure.

You might want a faster shutter as that helps to reduce blurriness from motion or camera shake and you get a sharpness to the image. But sometimes the use of a long shutter brings an artistic view of the image you are doing.

2nd side: Aperture

Aperture is the measure of the lens being open. Your aperture is often referred to as f-stop or stop. A narrower aperture or higher f-number has less light to reach the sensor. While the wider aperture or lower f-number lets more light in to reach the sensor.

The difference of the two and the reason to use them is simple. Are you shooting landscape or a wide view, or are you shooting a portrait or something close? What you shoot determines which one you want.

Landscape view you would like a narrower aperture. It will let you get a larger depth of field. While the wider aperture you want for portraits, it will isolate a subject.

3rd side: ISO

ISO is where you can work with the sensitivity of the digital sensor in the basic of terms. Working with less light, increase the ISO. You have to monitor the image as more ISO will increase the noise and give you less detail. While at lower ISO, the sensor will have to gather more light.

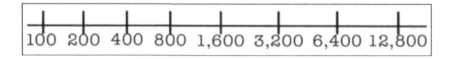

What does it all mean together?

For some photographers they have their set correct exposure. But each of us is different and our image of what we want out of a photo. If you go out with a friend and both take photos of the same thing/person, you will want different angles, different light exposure to different color sets. You are unique and when you take photos that uniqueness will come out in the photos you take.

Now that I explained what each one is, I will explain how each one

can help with taking a photo and how you want it to look like. As you can see, each of these sides of the triangle actually deal with light. One from how much light is present, to how much light to let in and how much light is "wide terms" to let in.

1st: **What do you want from the photo? Do you want a single object or do you want a photo that stretches out?**

Aperture

2nd: **How dark is it and do you need to up your ISO so that the small amount of light will be let in?**

ISO

3rd: **Is the subject moving?**

Shutter Speed

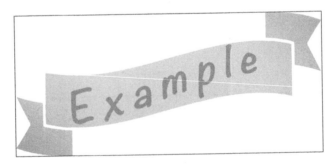

If you are shooting with plenty of light outside, then your ISO can be all the way down to 100. So now you only have to decide on Aperture and Shutter Speed.

If it is dark, then up the ISO and wider Aperture to get more light on the subject.

There are hundreds of combination that you can use for your exposure. I suggest playing with combinations on each photo you want to take so you get a feel of what each of the sides gives you.

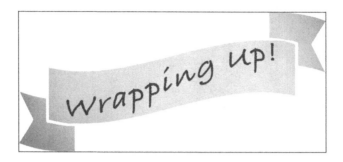

• *Understanding how the three parts of the Triangle effect your photo will allow you to compose shots that are properly exposed.*

EXPOSURE

*S*o now that we understand the Exposure Triangle and how it affects our photos, let's talk about Exposure as a whole and look at some different ways, we can change it with our iPhone.

If you set up your iPhone settings the way I have mine, you will have a little Exposure slider on the top left of your photos.

This is what the icon will look like.

This is what the top of your phone should look like.

Now, as we talked about before, our Exposure is controlled by three things. The sensitivity on the electronic sensor (ISO) the time that the sensor is exposed to light (Exposure time or shutter speed) and the size of the hole through which the light is being gathered (Aperture)

The basics of Exposure are just detailing how dark and light you want your photo. If you don't let in enough light, then your photo will be underexposed. Too much light and it will be overexposed. Most photos you shoot is done with the attempted goal to get as much detail as possible in the photo, so you are always trying to balance the exposure to get the cleanest crispest shot possible.

Let's look at how adjusting our settings a bit is going to radically change a photo:

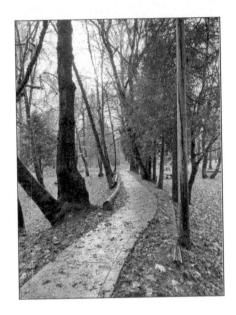

This will be our base photo that we will work on today. The Subject of our shot is going to be that nice curvy sidewalk, accented with the trees and autumn leaves. My iPhone decided that these were the base settings that it wanted to shoot with, let's see if it was right...

In each of these examples, I will show the Exposure setting that I used and then the final photo below it.

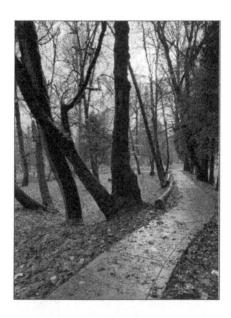

Wow, that's really dark. I underexposed the photo here. You can tell its autumn, but all the color separation and detail is now gone from the leaves. It looks flat, muted. Without detail. Look at the tree in front compared to the base shot. And though I can still see the sidewalk, I like very little about this second shot.

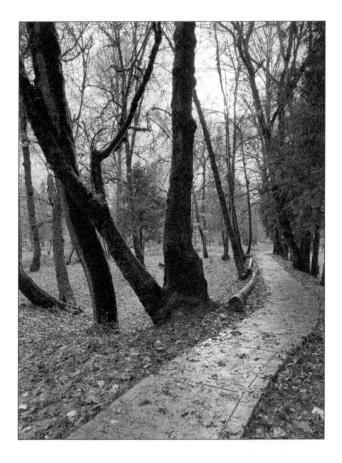

This shot is done at 0.7-

It's a lot better than the one at -1. There are more colors in the leaves but Im still lacking a lot of details and the shot is still very underexposed. Moving in the right direction, but far from correct.

This shot is done with an exposure level of 0.

Now this is what Im talking about. A simple photo. It's dark where I want it to be and light where I want it to be. My subject is clear and unburied, I can see color separation in the leaves, and the trees look properly lit. Some people may call this a touch overexposed, but it was a kind of what I had in my mind when I shot.

This shot was done at 0.7+

This shot is a classic over exposed shot. Look at the sky, see how it's almost glowing white? I can't tell if those are clouds, rainbows or the sun.

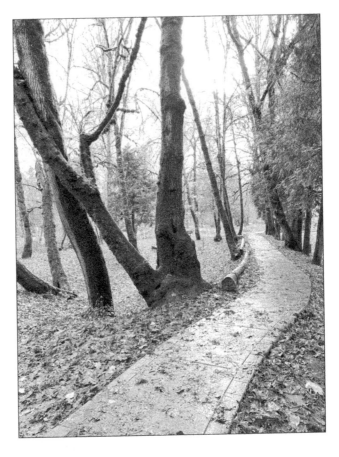

This shot was taken at 1.3+

This is very overexposed. The sky is bleeding through the trees up top.

Shot at 1.7+

Just for giggles.

So which one do I like best? Obviously the one with a good clean exposure. The one set at 0.0 actually.

The one my Camera took is fine, but I prefer my exposure.

So that's a lot of shots looking at exposer what are the takeaways?

Light is the most important element in all of photography. You need to figure out your lighting and make sure to have a balanced exposure. Sometimes a bit dark or light can work such as this shot.

Remember, you generally want to keep your blacks black!

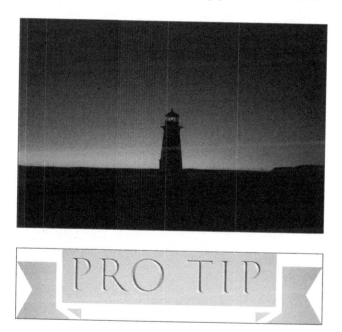

• *It is critical for a photographer to understand how to correctly Expose a photo.*

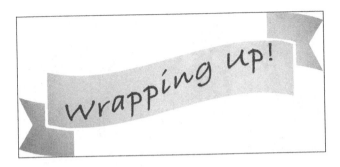

• *Remember what you learned in the Exposure Triangle chapter as well as this one and try to get a great photo that is neither over nor underexposed.*

SHUTTER SPEED

*T*his chapter is going to be really short.

So now that you understand the Exposure Triangle and understand how each part works with your camera, you might wonder how to change your shutter speed.

You can't.

Not by default, at least. The stock camera app gives you no option to control your shutter speed and controls all of this through the AI.

Only by using third party camera apps do you gain access to your shutter speed.

I hope to do an update to this book later on talking about some of these third party apps, but wanted the core book to be using the tools that come with your phone. Some of you may with to purchase more software tools later on down the road, and we will get to all of that. But for right now let's not focus on shutter speed yet.

FOOD PHOTOGRAPHY

ood Photography has been rising in popularity recently. And why not? Everyone loves snapping a shot of lunch and posting it up on Instagram so all of their friends can salivate over the delicious treats. Rather, at the local eatery and cupcake shots to at home breakfast sandwiches, food is in.

I like to break food photography into two different types of shots. Foods and foods with people.

Food shots are straightforward. You want to take some amazing photos of delicious looking food. The food is the center point and everything else is background noise. Sometimes people take rather artsy shots where thing bring in filters, odd lightning, and the rules of third to do a bunch of things in a shot. And you can do that if you wish, but I find clean and simple photos to be the way to go here.

These are basically the same photo from the same room. In the top

one my overhead light is set warm and I attempted to get a very artsy feel from the shot. The bottom one I had my overhead lamp on cool and shot in a well lit room.

Lighting as always is key!

Both are great shots! But one shows a bit more clean and the other one is more art. Like all photography there is a bit of creativity and art in how you get about shooting, when in doubt take both!

Same warm light, same look.

Improved and clean overhead cool light.

PRO TIP

Food Photography, like any other types of Macro photography require a keen eye for lighting. Shoot with many different types of light and move it around. You need a well lit area and external overhead lamps will help with this!

When shooting Macro food photography it can sometimes pay to get a balance between in focus and just a touch of bokeh. A little bit of blur in the back of the food will really make the front pop.

I know I said don't get artsy with it, but you can skirt the line just a bit to get a little bit of pop! Just be aware of your lighting and focus when you work.

You can take photos of your food from the overhead view. This is the common way that we look at food and thus interact with it.

But Food, like many things look entirely different from a different

Point of View. Photography allows us to change the angle and give us a unique perspective that we would not have gotten otherwise!

Cheese is your friend.

Just because you need to control your lighting does not mean you need to make all shots brightly lit. There is a lot of freedom in darker shots with food!

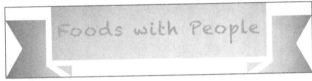

Foods with people is simple. You either highlight the food or high-light the people. If you are highlighting people see the other chapters on how to shoot people, you just have food in the shot. If shooting food, focus on the food.

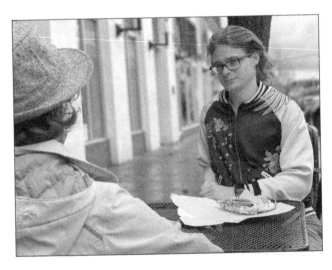

Portrait mode should be your go to here, and I blur the background to focus on my subject.

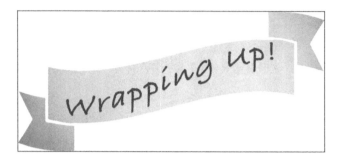

• *Pay attention to your lighting*
• *Clean shots generally look best*
• *Use different perspectives*
• *Centered photos show off what you are working on. The Rule of thirds generally does not apply to food.*
• *Use focus to really highlight the front of the food*

PORTRAITS: PART ONE

*F*or many people, this is going to be the most important chapter in the book. Because of the amount of things we need to work on this chapter will be broken up into different parts. The first two parts will deal with Portrait mode with people, the third with objects and landscapes.

Portrait photography, sometimes called portraiture, is the part of photography that focuses on capturing the personality and characteristics of that person. Although shooting landscapes, mountains and trees may be beautiful and rewarding, most of the photos we take are of loved ones.

A great Portrait photographer can catch the emotion of the surrounding people. They can work a wedding, family photos, photography sessions, senior photos and so much more!

Portrait photographers work their skills in so many situations. It is not impossible to do street photography and work completely on Portrait works. You can see them working corporate events. They can shoot key roles in weddings, the possibilities are endless. Anytime there is a person, and that is your subject, you are a Portrait photographer.

Mostly we are going to be using the photo mode "Portrait" to take our shots. Portrait mode the amazing new Computational Photography to take amazing life like shots of your target.

Let's go through a little about what Portrait mode is and what it does to your photos. Portrait mode uses a software blur to recreate an effect in classic photography that we would refer to as Bokeh. Bokeh is the artistic quality of blurring out parts of the image and making them out of focus while keeping your core subject in focus. By changing the aperture shape and using certain lens aberrations, you can create different Bokeh effects for your photos.

In simple terms, you are composing your shot in such a way to take part of the image and bring it out of focus. This causes the parts you have in focus to really snap and stand out from their backgrounds.

This may seem counterproductive at first. I mean, don't you want as much sharpness in the photo as possible?

That depends…

Let's look at an example here:

Photo taken with the wide lens and neutral balance and composition.

What is wrong with the photo above? Is it out of focus? Over exposed? To Dark? Boring?

Nothing is wrong with the photo. It's... fine... It's also kind of bland.

Let's flip over to Portrait mode now:

Photo taken in Portrait mode under the same conditions.

See how our subject has not moved, but we have a completely different shot. Not just from the angle that is applied or from any settings, but because I deliberately fuzzed out the background. The globe in the background adds a bit to my subject, but it was to dominate in the shot above. I wanted my focus to be about my subject and just let the surrounds melt around him. By making the background blur your eyes really only have one thing to focus on and that is exactly the way I presented the shot.

The Software AI will only create this blur effect on purpose when shooting actual people. It needs something to focus on. When it detects a face, it will give you a on screen warning telling you to move closer to the subject while it attempts to create the Bokeh effect behind them.

It will not work as well on animals or objects, but it is possible to get it to work.

Let's take another example:

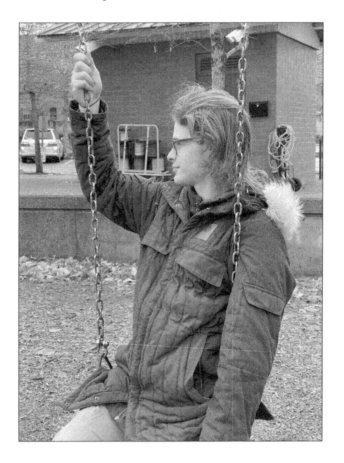

Nothing wrong with this shot either.

Everything is sharp and clear. Phone Photography from a few years ago would not have taken a shot with this much detail and clarity. I could be happy with this shot. And I may keep it instead of one in Portrait mode, but let's look at the differences.

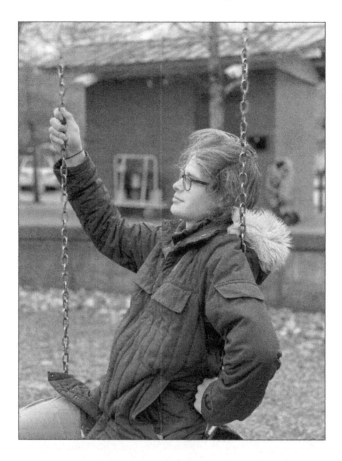

Our subject remains clear and to the front of the photo, while everything behind him fades away. The chain at the top of the shot even seems to disappear from the photo. Even though the focus is not increased in our subject by decreasing the focus in other parts of the shot, it makes him really pop!

Let's look at another here:

We could have brought some more light into this shot and illuminated our subject a bit more, but I decided that this would be a better composition here with our shot.

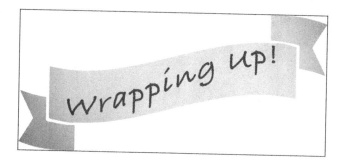

• *Ok, now that we have a basic understanding of Portrait mode, let's get into how it works in the next chapter.*

PORTRAITS: PART TWO

*S*o how does the Pro Max get those backgrounds to blur?

Imagine if you could take your photo and separate it into parts. In one part you have your subject and in another you have the background. You then take the background and make it out of focus, but the subject you leave in photos. Then merge the two photos together.

Let's look at another shot:

This is a great Portrait shot of our subject. But let's look at the steps for a moment. The one he is sitting on is still pretty much in focus. See how the steps get blurry the further away you go? And each step as it goes higher is a bit more blurry than the one before it? Same thing with the leaves. Look at the ones on the bottom step. And then look at the step above it and the one above that. See the additional blur effect as we move away from our subject.

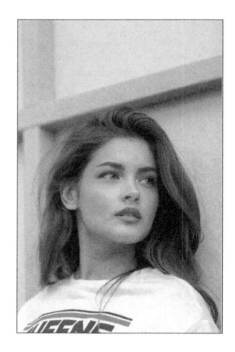

See how our subject and her shirt are in focus, but the wall in the background in not? It snaps your eyes right to our subject.

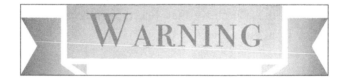

One of the minor side effects of Portrait mode is that it alters your exposure slightly. In many shots, like the one above, it adds just a touch too much under exposure, so remember you may need to bring that up a touch now and then.

Like so:

This is what Apple is talking about when they use the term Computational Photography. By using groundbreaking sophisticated software, you can do things with hardware that you may never have dreamed of before. Let's think about it from a hardware perspective for a moment. The shot above looks great but is just a touch too dark.

To buy a traditional Camera, you need both a body (the core parts of the camera) and a Lens and some accessories. To get a photo like the one above you need a 58mm lens (Give or take, some wiggle room here) to make that shot happen. Let's say this puts you back $500. You then have the hardware in your hands to take this type of shot. But Apple and their sophisticated camera AI can use Computational Photography to separate the two parts of the images and create a very similar, if not perfect, effect.

There are drawbacks, of course, but it's amazing how much this Camera can emulate much larger, bulkier and more expensive set-ups. Maybe in a few years we can go even further.

Will it take over? Has it already?

Who cares. This is about you getting the best shots you can right now. And right now this camera takes amazing buttery Portrait shots.

Let's do another one:

Standard

Portrait Mode

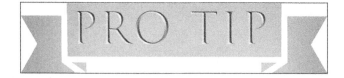

To get the best Portrait mode shots possible, make sure there is both enough light and a contrast between the background and the foreground.

So let's work through the shot above. Once again my subject stayed in the same amount of focus, but I blurred the background. What I want you to pay attention here is to the jacket. If you looked at the first shot above, everything looks in focus. Focused enough.... But on the Portrait mode, see how the embroidery on the jacket stands out more and is more detailed, sharper and defined? Especially the flower part on the right and the petals? The color is also going to be changed a bit as well (because we have a slightly different exposure level as it switched from wide to Portrait mode).

So here is a little secret about Portrait mode. Or any mode shift, for that matter. As you change through the different lenses, it is going to force the AI to retake its focus lock. It can't carry over focus to a different lens and needs to re-look for that focus. Because we don't manually adjust focus on the Pro Max, this can cause things to not be as sharp as would be possible if doing it by hand. The benefit of that is super blazingly fast auto focus. When you switch from the wide to the telephoto lens, you are forcing the camera to search for a new focus and will sometimes get things much sharper in detail than you would have otherwise!

At first you may think that blurring the background gives you more focus on your subject, but this is just an optical illusion. What is real however is the iPhone refocusing on your subject? Be aware of focus at all times!

Do I want to focus on the woman or the forest? Who is my subject? I can blur that background and focus solely on my subject!

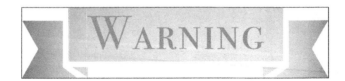

Some people refer to the Bokeh created from a Phone fake because it uses software to simulate the effect instead of real hardware. This could be no further from the truth. There is a difference between a true shallow Depth of Field and the one you get out of your iPhone, but I think it does an amazing job of simulating Bokeh adjustments. And if it makes better photos, then what would have been done without it, that's a win-win!

You don't always have to get a crazy amount of blur, sometimes just a small bur effect is what you want.

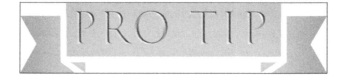

You can get two different subjects in focus while still blurring the background if they are close enough together.

• *Don't shoot every person in Portrait mode. It's just a tool in the box. Use it when it improves the composition, don't use it when it takes away from it.*

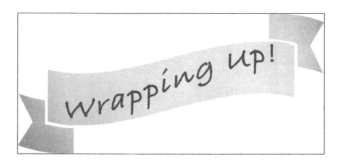

- *You now know how and when to use Portrait mode! In the next chapter, we will talk about using it on things other than people.*

PORTRAITS: PART THREE

*N*ow that we have gone over Portrait mode for people it's time to look at a brief chapter about what is can do for objects as well!

Remember that just because the Portrait Mode is taken with the Telephoto/Portrait Lens does not mean it activates Portrait mode when you use the Telephoto lens. To activate Portrait mode, turn in on by selecting Portrait mode.

Photography is all about composition. As we have learned in previous chapters, how and what you incorporate into your shots makes and breaks a decent shot to something amazing. We saw in the previous chapter how we can use Portrait mode to make our subjects pop out

from the background, but we can do the same thing with honestly any object.

Let's look at an example:

It's the holidays, and the Holly is out everywhere. I took this shot with the wide lens and because of how close I was to my subject and how far away the background is; it got a nice natural blur to the background without portrait mode.

But it looks kind of messy. Like I tossed it together with no actual intent to the composure, which is obviously not what I wanted.

Instead, I shot this:

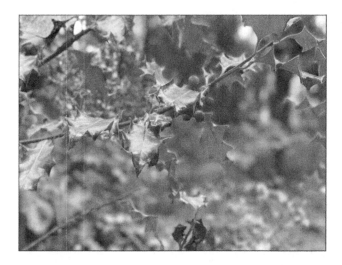

This shot was done with Portrait mode and I turned the exposure down a single step to 0.3-

This shot is much more balanced and I think really shows off the leaves from the Holly bush.

Portrait mode is not just for people. Wildlife and close Landscape shots can look great with a bit of Bokeh as well.

Portrait mode can be useful for Landscape as well.

This tree deserved to stand out on its own. My Mini turned my exposure down again, so I had to turn it back up just a touch.

We will talk about Landscape shooting in a later chapter, but this is a good point to mention that Micro photography belongs in Landscape as well.

• *More Blur is not always better. Think about your composition and add the right amount of blur you can add and how to improve your shot.*

Hopefully, this opens up your eye to Portrait mode. Next chapter we will talk about how to manually adjust it!

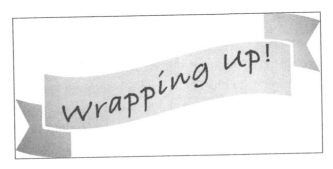

• *Portrait mode is going to add a blur to your photos, rather person or object. How can you best use it to make your subjects really pop!*

CHANGING THE DEPTH LEVEL

*W*e have now looked at many shots taken with Portrait mode and spent time understating blur, focus and composition.

But what if the AI does not give us the amount of blur we want?

Everything so far has been taking whatever the phone gives us for Portrait mode and accepting it, but we have some tools and control options to allow us to adjust things the way we want.

Portrait mode A.I. does a fantastic job of giving you the correct amount of blur. If I make adjustments, I usually take a shot with its recommended settings first and then make manual adjustments second. Once again following the rules of many shots.

Let's look at this shot here:

I took this shot in Portrait mode. It's not the tree I wanted, but the contrast and separation between the two different colors in the bark. The darks and lights in the tree. I don't care about the bushes, the river, the background. Just the tree. Portrait mode got me part of the way there, but I wanted more.

Enter my manual adjustment:

That's the shot I wanted. Compare it to the one above. Now the tree is not only the focal point of the shot, but it's the only thing in the shot at all. I needed this type of manual adjustment to get this shot. Let's go through how to do that.

Let's look at Cthulhu here:

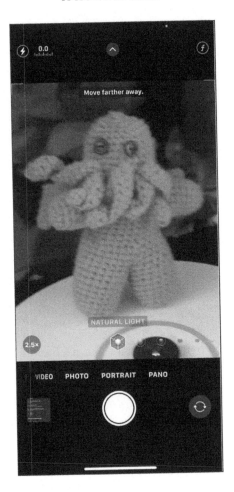

So we have already selected Portrait mode and are going to work on how to make manual adjustments.

First lets click on the up arrow here to get to all of our camera settings:

That should unlock all of our options down underneath our photo:

The one we want is all the way to the right. It looks like a F.

That F stands for focal length, and it's going to be used to adjust our Aperture.

Once selected, it will bring up our focal length adjustment bar.

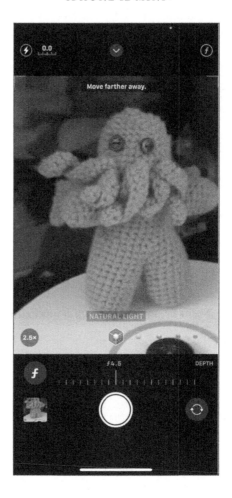

This bar naturally sits at F4.5. We can slide the bar up and down to different focal lengths to modify the depth in our shot.

• *Just because you can adjust the depth in the shot does not create depth when there is none. You need to have actual depth in the shot to make any actual difference with a blur effect. You can only modify the shot, not magically add things that are not there.*

Look at this record. There is no depth here, so the entire image just gets blurry. No point to focus on, not close enough for macro and not depth, nor lightning. This recipe will create a poor photo every time.

Let's work on our subject now:

Im going to take the Focus to 1.4. Because there is some depth behind my background, we will produce a nice little blur on the shot!

If you're looking for less blur, just up the F stop to a balanced level.

 • *You can also adjust the focus by moving closer or further away from the subject. This will adjust the blur and then you can manually adjust the F stop to bring the Aperture where you want it!*

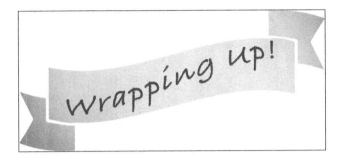

- *That is a detailed wrap up on Portrait mode.*
- *Remember to shoot as it gives it to you, then make your own adjustments.*
- *Portrait mode works for more than just portraits!*
- *Balance your shot.*
- *Composition, composition, composition!*

USING FILTERS

*A*pple has always worked hard to bring us the best software and hardware tools to elevate our photography. One of these tools is filters.

In the old days, we had to use hardware filters to create new scenic effects with our shots. These filters would attach to the front of the lens and change how the light came through into the camera and thus change our shot. In recent years, makers of photo editing software and even camera makers themselves provided us with software filters that we could apply directly to our photos. It's fast, clean, and can get some really interesting shots!

To access your filters, open your camera settings by hitting this arrow pointing up:

After that, it will bring your camera settings down at the bottom.

See that one all the way to the right? That is your filters.
Let's give it a click:

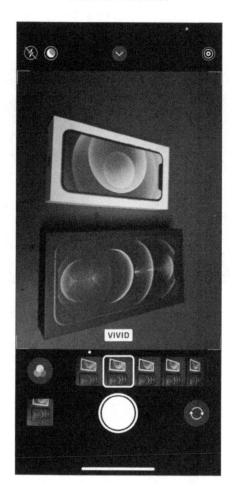

This will bring up all your different filters. Some of them will allow more light and make your shot brighter, others will turn down the exposure a bit. You really have to see them to believe just how much of a difference they make to your shots.

These filters are Original, Vivid, Vivid Warm, Vivid Cool, Dramatic, Dramatic Warm, Dramatic Cool, Mono, Silvertone and Noir.

Let's look at a wildlife reserve and see how filters change these shots:

Can you believe these are even the same photos!

Filters can be applied later in the photos app, but I always apply them to the photo live while I'm shooting. (When I say always I mean almost always…)

So get out there and try out those new filters! Don't give up an opportunity to turn this:

Into this:

And later on you will apply even more filters in editing, some from Apple and other 3rd party filters as well. If you ever see a shot online that looks impossible, it may have been done with a 3rd party filter.

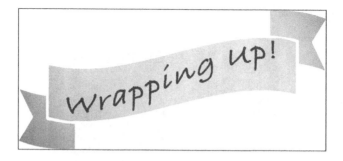

• *Learning Photography is part study and part play. Go out and play with your filters. Pretty soon you will start coming up with a bunch of shots that look completely different from your standard works.*

LANDSCAPE

*L*andscape photography can be some of the prettiest work you can do with a camera. Though many people think of Landscape as the big large epic shots of nature, it can be small, tight and microscopic if you want it to.

Landscape is basically just photography the shows the natural world. It is the art of capturing the outdoors in a way that allows your viewer to immerse themselves in the scene. The spirit of the outdoors.

Landscape photography, in many ways, is the easiest type of shooting to do. Everything in nature looks beautiful. The world will literally improve your photography, just work with it.

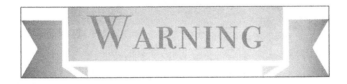

Just because nature is amazing does not mean you should ignore composition. Figure out your subject and how to accent it, like always.

Let's look at a photo that will challenge our idea of Landscapes:

We often think of Landscapes as grand, but they can be quite small as well.

Remember that we are connecting with the spirit of nature.

Small

Medium

And Large

The great part about shooting any kind of landscape shot is it really

puts you in complete control. In other types of photography, it limits you on how you can frame the shot. Is it really Portrait photography if you are 50 feet away from your subject? Can it be wildlife if you can barely see the wildlife? But with Landscape you are in complete control over the shots and what you want to frame, the how and why.

Grand and epic

All about the seasons

The sun is the star!

The high pace of the city.

See what I mean? Landscape is everything. It's just the natural world, or sometimes even the built one.

Landscapes benefit perhaps more than any other type of photography from shooting in various light conditions. Find a place that you want to shoot and hit it in the morning, then at noon and again at night. Go when it's clear and bright, go when it's overcast.

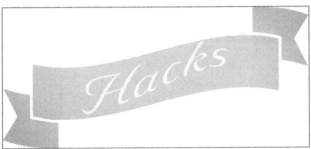

Change the angle. We are all used to seeing things at eye level, so try shooting lower or higher than eye level to get a unique perspective on Landscapes.

• *Get super close to your subject, as close as you can while stilling getting your shot in focus. Look at it afterwards. Did this new composition add elements to the shot you enjoy? If not, you might want to reframe the shot.*

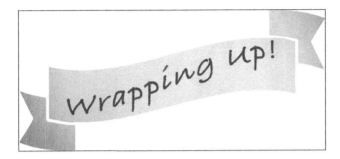

- *Go on walks outside.*
- *Take your Camera Everywhere.*
- *Remember that it does not have to be epic for you to make it epic.*
- *Small, medium and large.*

HDR VS. NO HDR

*H*DR stands for High Dynamic Range

Every different Camera deals with HDR differently, but we are going to talk specifically about the 12 mini here. The mini works to improve the quality of the photo by modifying the color and light and thus, the detail by modifying the bright and dark areas of your photo.

Dynamic range is just a way of saying the space between the darkest and lightest parts of your photo.

As good as the camera is on your iPhone, it will really struggle to capture detail in both very dark and very bright areas when you are trying to do them at the same time. This is called a high contrast scene. Your eye can see these things as the dynamic range in your eye trumps your camera by about, oh I don't know, 100 times.

Give it a test. Go out at night at dusk and shoot a photo of the cloud overhead and see what highlights and light area you can pick up out of that photo. Now look at it with your eyes.

Phones really struggle with exposure on high contrast scenes. HDR tries to fix this.

HDR Photography captures the brightest and darkest parts of a

scene at the same time. It takes 3 photos, one overexposed, one under-exposed and one standard exposure and then uses software and AI wizardry to stitch them together into one image. Many people think HDR captures more light, but really it just combines many shots into one to get the best exposure it thinks can be done.

When should I use it?

They made HDR for Landscape Photography. Consider you are at the beach shooting the ocean. The sun is bright overhead and shining on a large series of rocks. You position yourself to get a photo of those rocks but want the ocean in the background. The sky and the ocean are different color tones but still well lit so they come out great, but the shadows cast by that rock have no detail what-so-ever. The reason for this is that your shot is going to be overexposed because of the sunlight, but HDR will bring detail to those shadows, picking up things you never would have beforehand.

HDR can also work great when you are shooting at something that has the light source behind them. This will make your subject pop against the bright background by bringing out the details in that dark-ness. Let's use our example above and say someone stood next to that rock at the ocean. You could bring the exposure down and darken the whole shot or overexpose the person, but HDR will get you both.

When should I turn it off?

Whenever you want the high levels of contrast without bringing out details in the darkness. You can get some really interesting shots by not getting all the details, such as when you are trying to create a silhouette photo.

You used to have to turn it off when shooting a moving subject as well, but the Pro Max is significantly better than last year's iPhone at HDR plus moving subjects.

. . .

When in motion.

Because the camera has to take 3 different photos and combine them together its best if the camera can stay as still as possible. A tripod is preferred. The Mini has some software wizardry that is amazing and will align those photos back together even with movement, so you don't need to be perfectly still, but the less movement the better.

Pros

• It's closer to the way your eye sees it
• You can capture far more detail in high contrast scenes
• Shooting outside the sky and sunlight often leads to overexposed shots, HDR will balance your shot and bring detail into your shadows

Cons

• Some people feel it can make your photos look not real/overly processed
• You need to keep your camera as still as possible because it's taking multiple shots

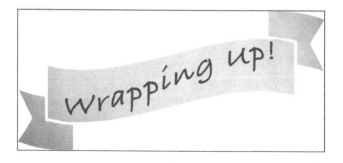

• *HDR is a tool, not a hack that improves every photo you take.*

• *Use HDR when any photo would have parts that are too bright or too dark and you want to combine them*

• *Use HDR when you look at your photo and it appears too dark and the shadows lack detail or the highlights are too bright in the same shot*

DIFFERENT ANGLES

I touched a bit of looking for different angles in other chapters, but wanted to talk about it again here.

Because we have already gone through the importance of composing a shot by looking at the elements around the subject that add to or take away I won't refresh on that, but I want to give a few photographic examples of how to look at a different angle.

At a downtown park, there is a wood bridge that connects two sides of the park with a lake in the middle.

This shot was taken straight on. It's like I said, a bridge that goes from one side to the other. The Bridge is our subject. But what accents our bridge here? What detracts from this photo?

Let's look at two other shots:

This one is taken slightly off side, and before I hit the ramp with the standard wide lens. I had to ask myself what part of my subject I wanted to highlight? Sure, the bridge is the subject, but what part of the bridge was the centerpiece of my photo? I decided that the ramp and the wood would be my highlight here instead of just the bridge, but I still wanted my core subject to be the bridge. This caused me to off frame slightly using the Rule of Thirds, which actually frames my shot up more with my subject.

Heres another:

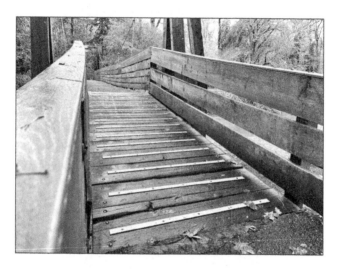

I had the same ideas as the shot above. Still with the Bridge as my subject and wanting to highlight the wood and the ramp, but I feel the length of the bridge got lost in the shot above. I really wanted to get a feel for how long this bridge was, as the bridge is still my focus point in the shoot. To do this, I had to gear really low to the ground but still lean a bit up and out.

Decide what your subject is. Frame in your mind, not with your camera. Use your eyes. Ask yourself what makes a wonderful photo? What takes away from your subject? Do this shot first. The good one. The one you see. Then afterwards look at it from a different angle and get a different composition. This is the correct way.

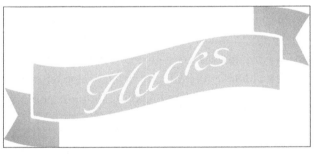

Find a subject that you want to take a photo of and look at how you think it should be composed and then immediately toss that away and go not only to q odd angle but a composition that makes little sense. Add errant parts, a tree here, an object there. Ignore rules, throw caution to the wind, and shoot creatively from the hip. Shooting like this can be quite liberating sometime, and you can learn a lot from it!

Let's look at another photo:

It's not a spectacular shot. There's not a ton going on here. But the composition brought so much to this photo that would miss otherwise. I want to make my composition as clean as possible but if I have to choose Im always going to go with interesting above anything else. Very few photos you take are going to be showstoppers, but the things you practice every day will build your skills for those special moments.

• *You can learn the most about composition from some of the worst shots.*

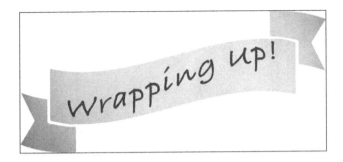

• *Looking for an Additional Angle is all about helping your composition, not hurting it. Use your judgement on what makes good composition but don't ignore something because it is not the first thought that comes to mind.*

COPYRIGHT QUESTIONS

*L*egal Disclaimer: I am not a lawyer. I am not giving legal advice, what I am giving is what I have researched and learned regarding United States Copyright law. This is from my own research, talking with people and experience.

Copyrights laws also depend on where you live. Please check your country's laws if you have anything that you are questionable about.

Street Photography is something that anybody can do. From kids to seniors. And posting those photos online for either personal or commercial we want to make sure we are not sued and we need to know what are rights are for when we go take those photos.

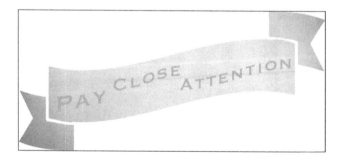

I call this the 7 rules of Street Photography.

1. The general rule of thumb in the United States is: If you can see it, you can shoot it.

Free Speech under the First Amendment of the United States protect us when we go out to shoot. As long as you are in a public place, you have a right to shoot. It gets touchy when you take photos of Government buildings, personal Works of Art, Military bases, and a few other places. Of course you will not want to take photos in a bathroom because of the Expectation of Privacy that people have.

That also goes from shooting photos into a house, even if they have the curtains wide open. You must be respective of the surrounding people and places.

2. What is a public place?

One would think you know what a public place is right. One would say that the shopping mall is a public place. You would be wrong. Places like shopping malls, theaters, amusement parks and stores have owners and you must compile with their rules.

If you would like to take a photo of a great-looking sandwich that you were just served. If the server asks you not to take photos, then you must do what he says. They have rights on their property.

This goes back to some places not being able to take photos for privacy, security or logistical reasons.

Also, if a sign is posted No Trespassing, don't go climbing over a fence to get a photo of an old abandoned barn that itches to be photographed.

3. Restrictions on Photography when it interferes with others.

Continuing with being able to take photos from the street, spot a great old time building and you must take that photo. That is alright, as long as you don't set up a tripod or cause a safety hazard.

If you stop the flow of traffic and become a nuisance, the police or security can ask you to move on. I know that in Disneyland/world you can't use a selfie stick. It blocks others and interrupts the flow of traffic.

4. What about people in my shots?

Are you concerned about the others that may pass by, or maybe you want a photo of an old trolley in use and people are on it? No worries. You rarely need a model release form. You have two thoughts, are these photos for personal or commercial? Selling stock photos? Posting on Instagram?

Simply photographing people, even police, don't need a consent. Are you in public view then the consent either verbal or written is unnecessary.

Of course, it does not hurt to get a written release form signed if you are posting them for commercial works. Common sense is used if you need it.

The rule is exceptions of privacy. Can you identify a person on site? Do they have tattoos, or something else that can be recognizable? Then it is best to get a signed form.

Also, you can't publish a photo that gives away private information. That goes in with taking a photo in a Doctor's office or an AA meeting. Use your common sense.

Also, if they waved you off, please respect their wishes and not post those online. They can't tell you to delete or take away your camera, SD cards or film without a court order, but do you really want the headache of the trouble it could bring.

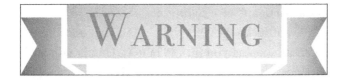

5. People will approach you.

People will come up to you, either for curiosity or just out mad that you are photographing them. Just remember to be calm and respectful. In this day-of-age you will get people who give you dirty looks and sneers. They have the right to be there, but so do you.

Speak with confidence and clarity so that there is no misunderstanding. Accept that they have a fear or concern. Explaining what you are doing and being open about it helps to clear the air. If you are told that is prohibited, then you can ask for clarification to the policy. Remember, if it is a public place you have the right.

6. Can I sell my photographs?

Now that you have some photos, you might think if you can sell them. Yes, you can. You own the rights to them. Even when you post online, they are yours.

Things get a little tricky. That goes back to public places and things. Did you take some photos that have an artist's sculptures in the background and you didn't see when taking the photos, you can't post those.

So you have the option, you just need to know the outlines of having it posted for sale.

Selling to stock photos online, or for advertising, they will require a model release form for any person who can be identifiable.

. . .

7. What about someone else selling my photos?

You may want to know what your rights are, and that is that you own the photo as soon as you hit the button. Unless you are hired for-work, then your employer is the owner. But as a freelancer for a wedding, you own those unless you sign a release to give the permission over to someone else.

You don't need to register those photos under the copyright law; they are yours. Allowing someone to use the photos doesn't give up your rights. You can give yourself some extra protection by adding the copyright signature.

It must include ©, copyright, or Copr. Plus year and the name of the copyright owner.

© 2020 Your Name

You can also add, All rights reserved. For an extra level of protection.

Adding a notice will not stop all people from stealing your work. It is up to you if you want to go after them.

EDITING

*E*very professional photographer will edit their photos.
I will not include editing work in this book. It's just too much to ask someone to learn photography and editing at the same time. It's a whole distinct skill set.

Does that make you an incomplete professional photographer?

Sure…

Thing is, editing is often harder and longer than the photography shots itself. It requires a long amount of time and many hours to build the skills you need. If I was going to include sections in the book on editing, which ones would I do?

• Reading the Histograms?
 • Using Lightroom?
 • Editing in photos?
 • On your Mac?
 • Which software?

It's not that you can't learn to edit, but for this book I wanted you to

learn Photography. I want you to be comfortable with the ideas presented in this book before jumping into the deep end and start editing. Honestly, editing is another book completely on its own. Once you edit your own photos, you will never go back. You will bring things that you never thought possible out of your photography and elevate your game to the highest level.

However, you can only edit what is in the actual photo itself. If the photo is crude, you can improve it, but it's still crude. I wanted to build a foundation that you could improve on before working on the edits. Baby steps. Just as editing is half of the photographic process, photography makes up the other half. To get great photos, you need both.

I have only edited about 10% of the shots in this book, (needed for one reason or another for teaching) The shots I included are just the straight shots I presented the raw photos with only using the default camera app. I could have included better photos than the ones I shot, but this is not about my photography. It's about yours. And to improve your photography, we work on your base skills first and then edit after.

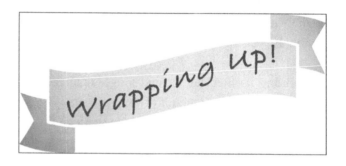

• *When you are ready to take that next step, jump into learning to edit.*

WILDLIFE PHOTOGRAPHY

he iPhone is not really intended to shoot Wildlife. But that does not mean we can't give it a whirl!

It benefits wildlife photography by these two things: Hardware Zoom and larger size sensors.

Hardware zoom is simple. The 12 mini has a bit of zoom, both hardware and software. Your wide lens shoots naturally at one distance and can hardware zoom to a bit more. You can use software to artificially zoom to a greater amount but will suffer radical quality loss to do so. With a more traditional DSLR camera, you could use a hardware zoom lens to get up to 400X and still maintain outstanding image quality!

Larger sensor size is another one. The larger your sensor size, the larger you can crop down while maintaining high quality. The problem with wildlife is that animals are very skittish and will run if you get too close. With a larger sensor, you can shoot from farther away and then crop down much tighter on the image to get a better shot.

These are pros to shooting with a more traditional set up, but we still can get some great shots with our iPhone.

First, let's define what Wildlife photography is:

There are two types of animal shots. Actual out in the wild and

more staged. The best places to get Wildlife shots is at your local zoo, local nature reserves or large undeveloped parks. The perception is that amazing wildlife photos coming from the wild are not very accurate. Most of the great animal shots that we see are very well composed portrait shots in a isolated environment.

I don't want to discourage you from backpacking out into the wild and getting animal shots, but that's just not how it's done. If you run into an animal from your local park, snap some photos! If you want really spectacular photos, go where the animal is.

Keep your eye out when you see something, it's likely it will be there on a different day and you can come get some fun little photos.

Impromptu visits from the animal kingdom can be fun as well.

• *Shoot in Burst mode. It gives you a much greater chance of getting a shot of someone in motion than you would have trying to frame the shot.*

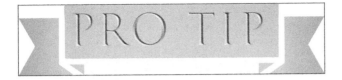

• *When approaching a wild animal, be careful and use common sense. Move slowly when trying to approach, but remember to be respectful of the animal and its environment.*

Birds are a bit hit and miss, but deer will sometimes pose for you.

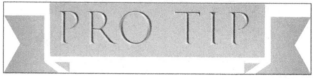

• *Apply filters and effects in editing later, instead of trying to do them during the shot. I don't recommend this for most things, but you don't want to miss a shot while trying to get your settings correct.*

Your local park can provide some great shots as well:

As can local farms:

And even pets!

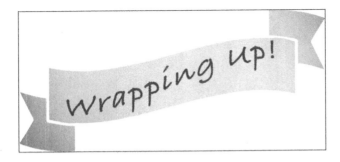

• *Your hardware is not working in your favor, so you have to get as close as you can to your subject.*

• *Shoots a lot of photos in Burst mode.*

• *Use low light mode if shooting at night*

• *Worry more about getting the shot and try to fix composition in edit*

• *Go where the animals are*

CITY PHOTOGRAPHY

 orking your skills downtown requires a different mentality than what we have used in earlier chapters.

There are many challenges of city shooting not present in other settings. The hustle and bustle of the city keeps everything very active and sometimes makes it quite difficult to get your shot. In a small quiet city park you will have no issue waiting for a person or two to pass to get your shot, but in a larger city you may wait hours.

So how do you get that shot?

First you need to adjust your mentality. Let's go through our rules of City Photography to learn how to get some great shots from downtown.

1 - People are a part of the city.

When most people think of city shots they think of buildings, scrawling architecture and skyscrapers. But most of them are devoid of people. People are just as much a part of the city as the bricks themselves. Don't avoid people. Shoot them! Shoot during busy times. Shoot during quiet times. Get one person walking crossed an intersection, or 13 people in a crowded elevator.

Don't avoid people. Use them!

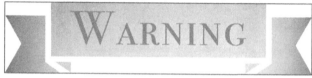

Many people dislike their photo being taken. Even though it's not illegal for you to be out shooting their photo, please be aware of your surrounds at all times and try to give people a wide breath. Folks can be quite jumpy. See the chapter about selling my photos.

2 - Get there early.

Everyone likes to sleep in. Take this as an advantage and show up before the city moves. You will have the perfect opportunity to get clean shots without people, or even better, a shot with just one person.

Don't be afraid to approach someone and ask them if you can take a shot. They may pose for you in a way you may not have gotten otherwise!

3 - Shoot in bright daylight.

Most of us see the city at day, in bright light. Our Camera operates the best in this manner and photos look amazing.

Because you're shooting in the middle of the day, be prepared for people in your shots. Take advantage of that in getting great shots of the hustle and bustle of everything.

Don't forget to use all three of your lenses in the city. Don't just shoot in Ultrawide, explore all the ranges with your different lenses.

4 - Shoot at night

Just because the city looks great in the day does not mean we should not shoot at night! Just be careful of how much light you are letting through. I like to focus on a single point of light so that my shot can stay in focus.

5 - Find a low viewpoint.

Sometimes when looking high, we forget to look low. Think in macro terms. Go get something that people walk by every day and take for granted.

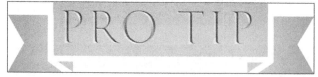

Don't forget to get high as well! You need to get above the build-ings to get a general overall shot of the city. Don't be afraid to go up and look down.

6 - Look for reflections in water.

The city gives us something we rarely get anywhere else. A bunch of different colors in our lights. You can capture this in a photo, but if you get it in reflections, you get a perfect example of the scale of things. It's an artistic way to do something different.

Be it large.

Or Small

7 - Go Black and White!

We talked a bit about using filters in an earlier chapter, but did not mention how much the city can really pop when you remove all the color. Old time buildings already have a ton of character and you can bring highlights to that character by removing color.

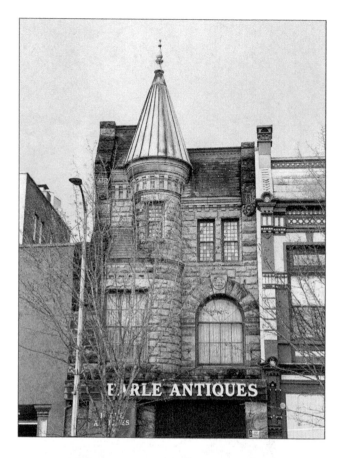

8 - Get the city lights

Look for the angles just outside or the city. Get something but make it your own.

• *Shoot your city! Who knows it better than you? But look at your city in a new light.*

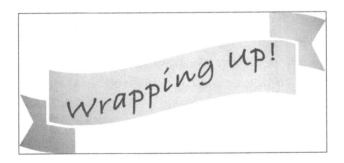

• *You got this! When going to shoot, make a checklist of the things you want to shoot but remember to keep your eye out for shots you may not have thought of!*

HACKING YOUR CREATIVITY

So now you have gone through nearly the entire book, cover to cover. You have learned how to use your iPhone and why you would do things in a certain way. You went to your local park and shot all the trees, had friends and family pose for you until they are sick of you. The local cupcake shop knows you by name, and you have filled more external hard drives than you can count.

And then you hit a funk. You run out of photos to take. I mean, how many times can you shoot your local park? Do you have to leave city? Go on expensive international cruise shoots too far off vistas?

You could do that, or you could jack your creativity through the roof and change your outlook.

Go some place new:

Try to visit some place that is new to you or you have not gone to in a while.

Going outside has a tremendous amount of benefits. It gets you up and moving; you get fresh air and being in nature has shown to help ease someone's funk. Being outside improves our creating thinking and nothing beats fog like a quick walk around outside.

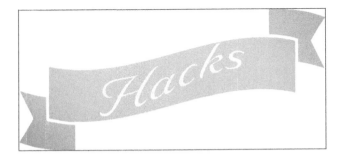

Take some time in your new adventure to move slowly and breathe. Take your time, don't rush through things.

Looking for a fresh perspective:

Most of us get stuck in a rut of shooting the same photos in the same spots in the same way. When you are feeling blocked, look for a fresh perspective. Shoot only using the ultra wide today. Do only Macro shots today. Shoot only with a filter you don't use today. Get close, get far. Move around. Lay down and shoot up, shoot down. Go through and look at your photos slowly. Did you find something amazing?

Do you walk the same route every day? Walk it backwards! Switch up your routine and see the world alternatively.

Learn new techniques! Do you only shoot landscapes? Incorporate some Portraits into your shoot, both Portraits in your landscapes and portraits on their own. Add to your toolbox!

Look at other works and connect:

Go online and browse. Visit Reddit pages and look at photos. Connect and talk with others. Allow them to inspire you and be willing to inspire them. It's amazing how much taking a step back from photos and interacting with another person will help you get better photos on the next shoot.

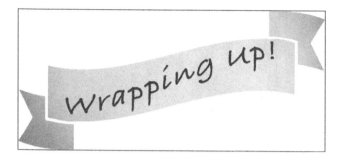

- *Go Someplace new*
- *Looking for a fresh perspective*
- *Look at other works and connect*

AFTERWORD

Time Lost Books, LLC

Copyright © 2020 Vincent Black

ABOUT THE AUTHOR

Vincent Black is a Professional Photographer shooting out of the Pacific Northwest.

He is an award-winning photographer with years of experience in both photography and teaching workshops and classes. Recently Vincent has started working with Cameras from mobile phones in the big push towards computational photography.

• Vincent has a B.A. in Photography.
• Vincent has traveled around the USA and abroad to hone his skills.
• Vincent has taught classes at the community college.
• Vincent has taught students between the ages of 8 and 88!

Vincent loves being outdoors and seeing what kind of wonders the world has. He can't wait for each and every upcoming photo shoot. You can see more of his books at his publisher Time Lost Books, LLC.

MORE BOOKS